ALL SMILES

by
BRUCE VELICK

CHRONICLE BOOKS
SAN FRANCISCO

Pages 69-71 constitute a continuation of the copyright page.

Printed in Singapore.

Book and cover design: Joyce Kuchar

Library of Congress Cataloging-in-Publication Data:
Velick, Bruce
 All Smiles / by Bruce Velick
 p. cm.
 ISBN 0-8118-0590-5
 1. Portrait photography. 2. Smile—Pictorial works. I. Title.
TR680.V45 1995
779' .2'092—dc20 94-17326
 CIP

Distributed in Canada by
Raincoast Books,
8680 Cambie Street
Vancouver, B.C. V6P 6M9

10 9 8 7 6 5 4 3 2 1

Chronicle Books
275 Fifth Street
San Francisco, CA 94103

To Denise, who keeps me smiling.

Acknowledgments:
Thanks to Nion McEvoy and Charlotte Stone at Chronicle Books,
to my agent Candice Fuhrman,
and special thanks to Denise Filchner
for her valiant assistance in bringing all these smiles together.

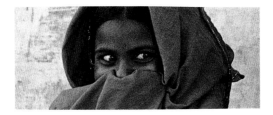

W hat's the use of worrying,
it never was worthwhile,
so pack up your troubles in your old kit-bag,
and smile, smile, smile.
George Asaf

All Nature wears one universal grin.
From Tom Thumb the Great,
act 1, scene 1, by Henry Fielding

Happiness is speechless.
George Williams Curtis

The thing that goes the farthest
toward making life worthwhile,
that costs the least and does the most,
is just a pleasant smile.

It's full of worth and goodness too,
with manly kindness blent,
it's worth a million dollars and
it doesn't cost a cent.

"Let Us Smile."
W. D. Nesbit

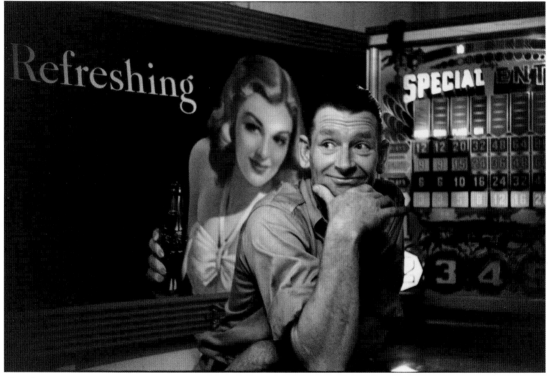

Plate 1.

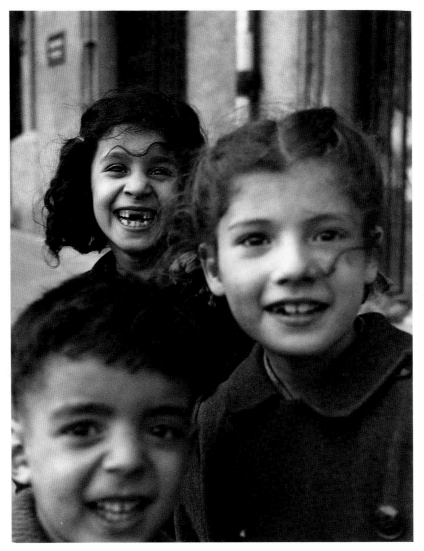

Plate 2.

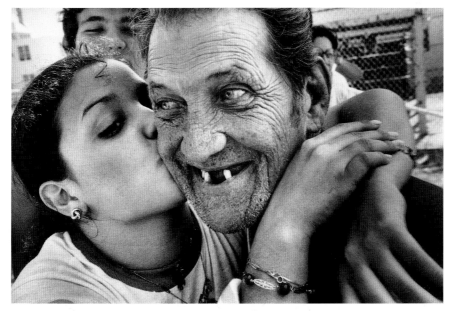

Plate 3.

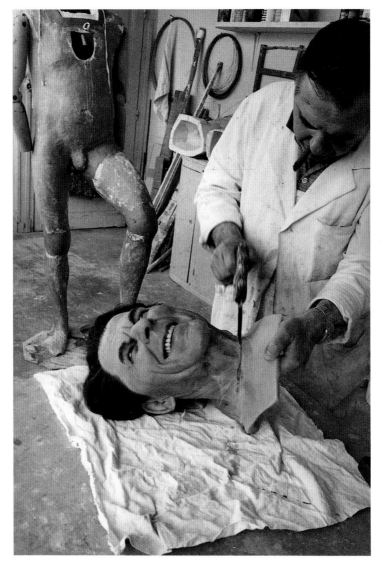

Plate 4.

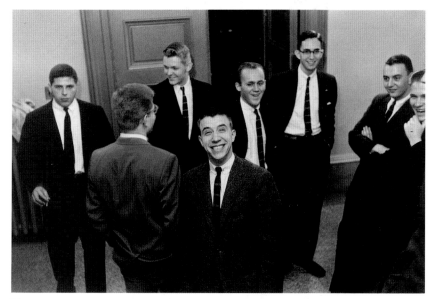

Plate 5.

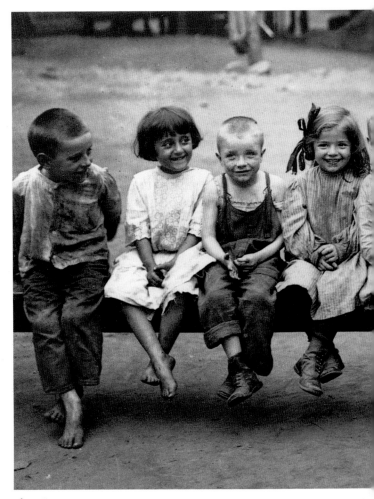

Plate 6.

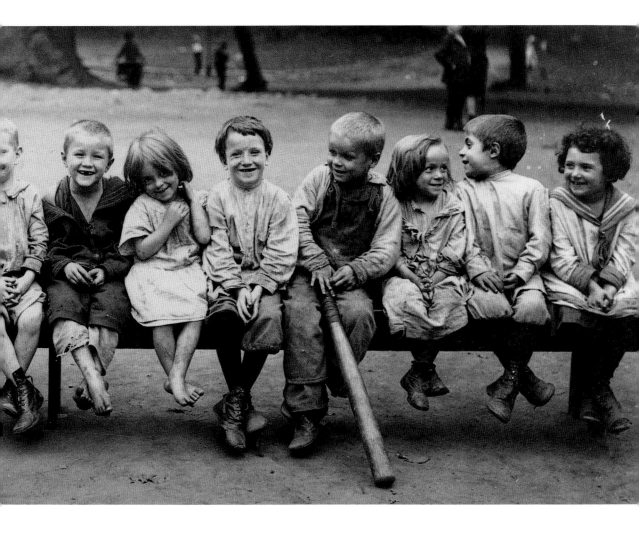

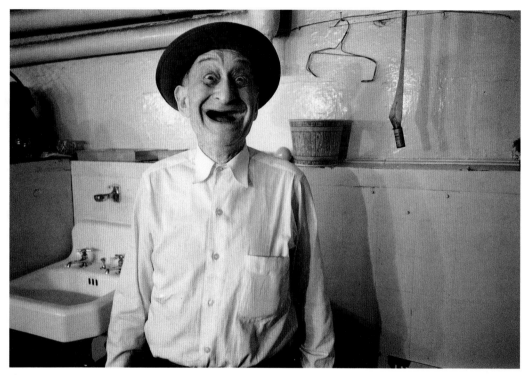

Plate 7.

Plate 8.

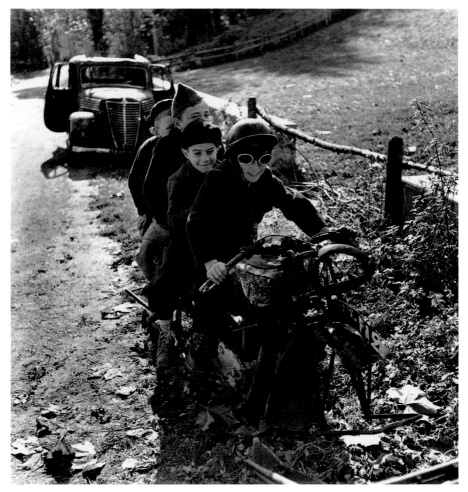

Plate 9.

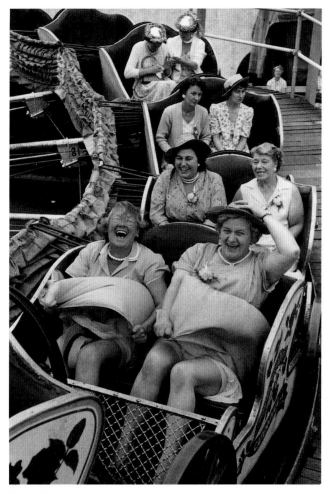

Plate 10.

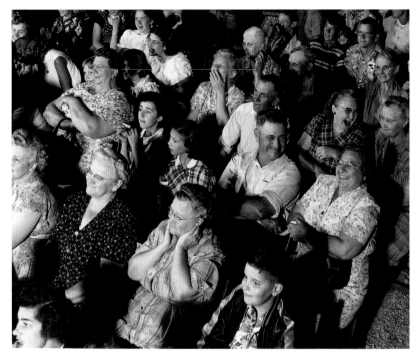

Plate 11.

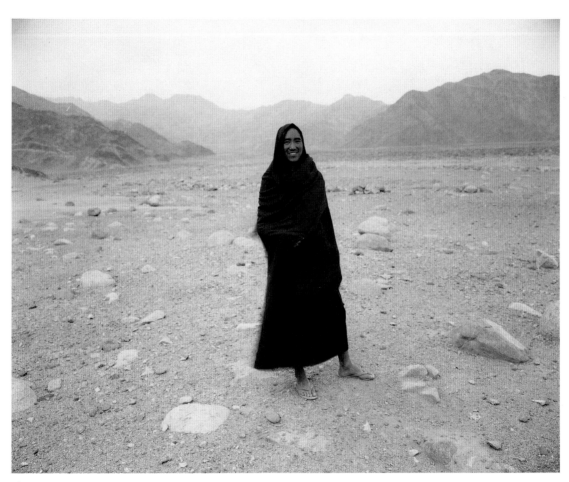

Plate 12.

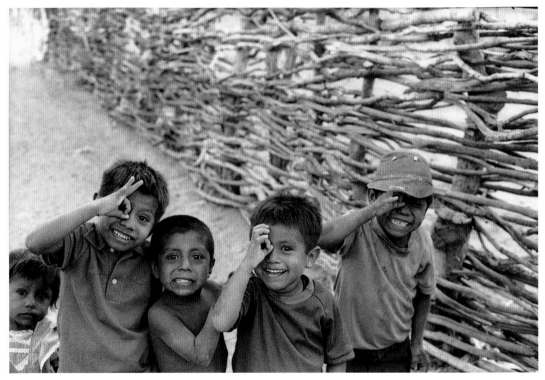

Plate 13.

Plate 14.

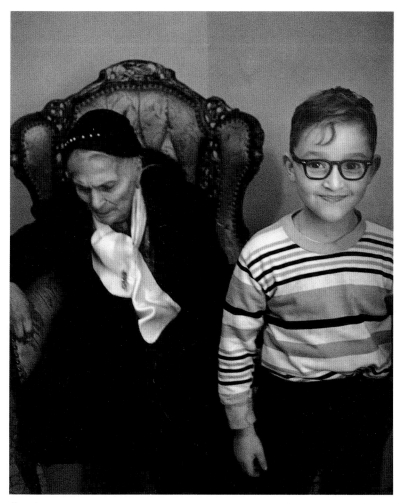

Plate 15.

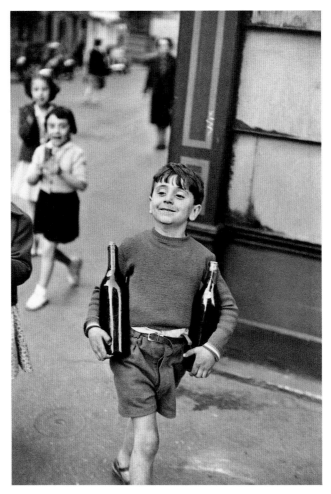

Plate 16.

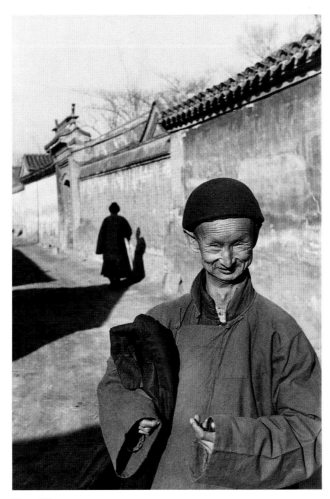

Plate 17.

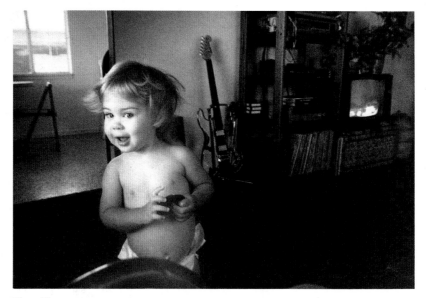

Plate 18.

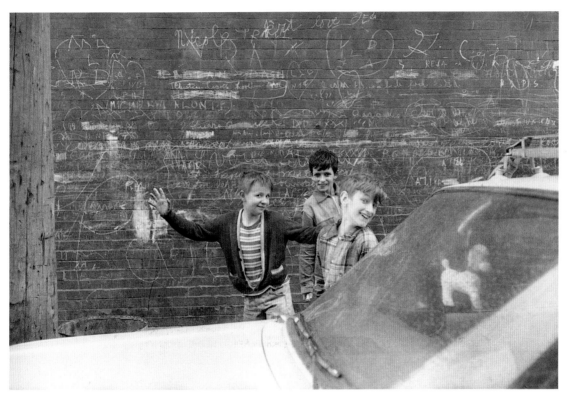

Plate 19.

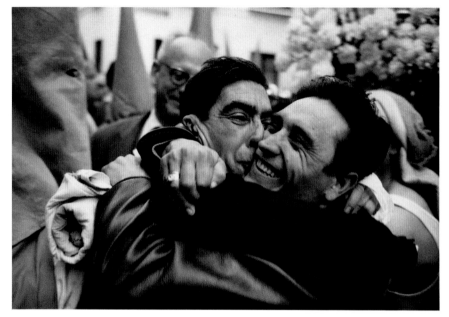

Plate 20.

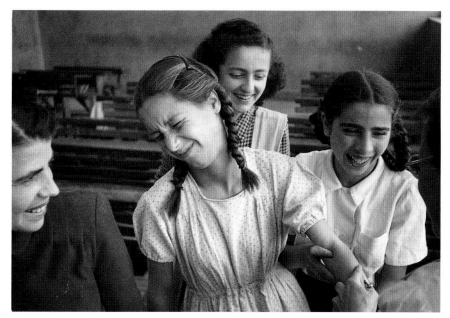

Plate 21.

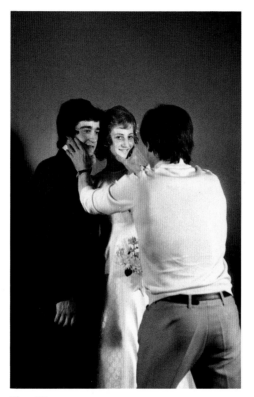

Plate 22.

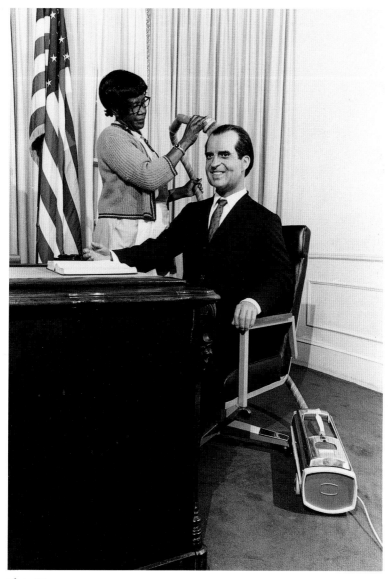

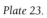
Plate 23.

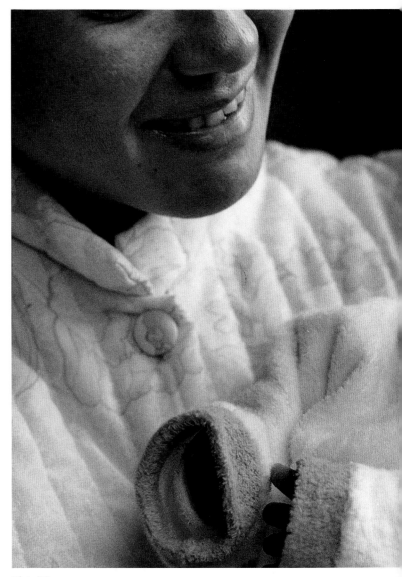

Plate 24.

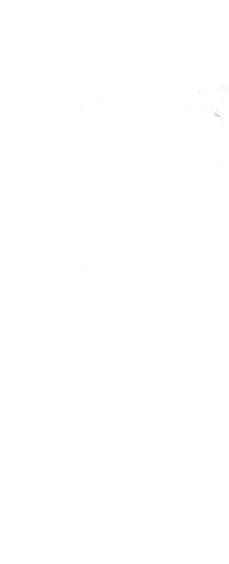

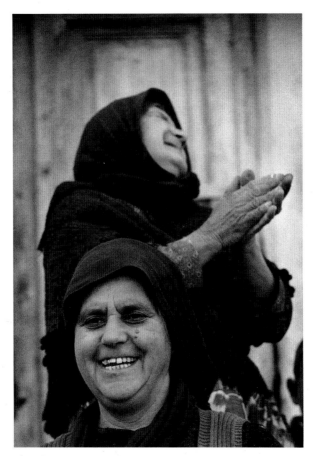

Plate 25.

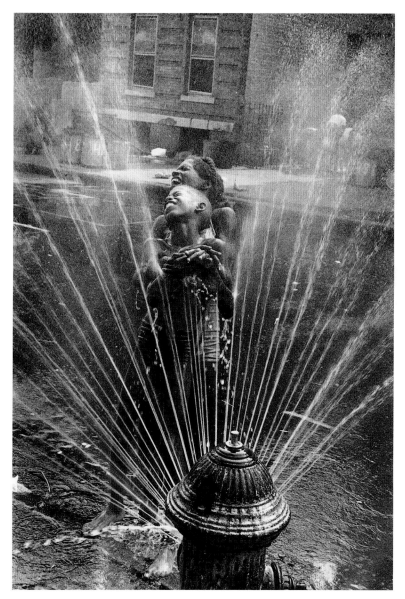

Plate 26.

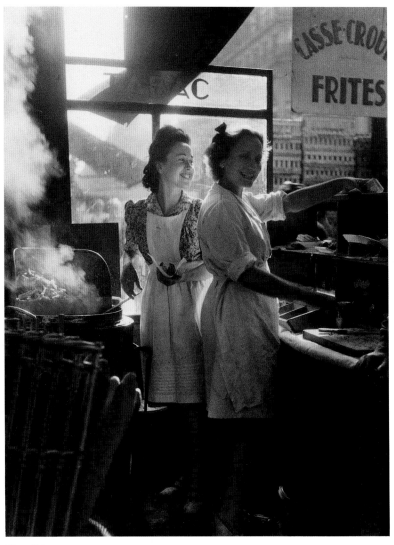

Plate 27.

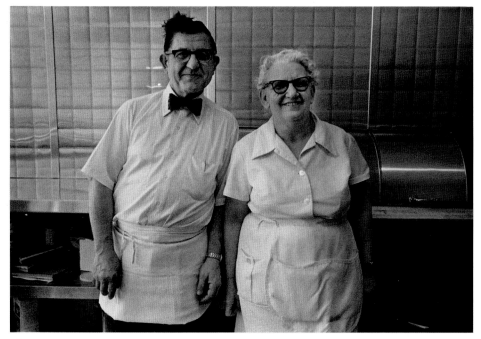

Plate 28.

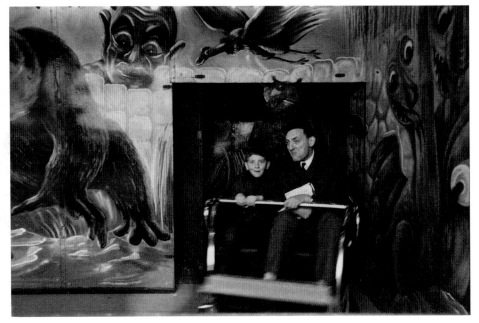

Plate 29.

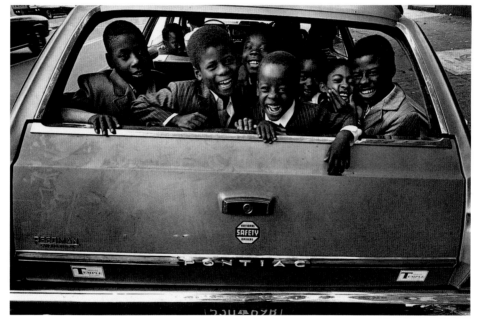

Plate 30.

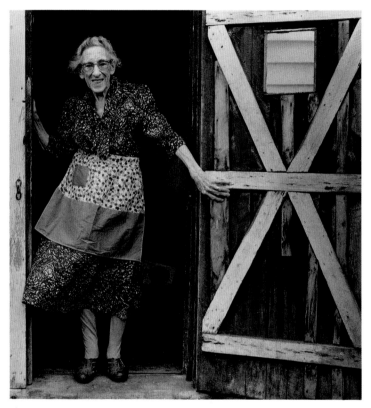

Plate 31.

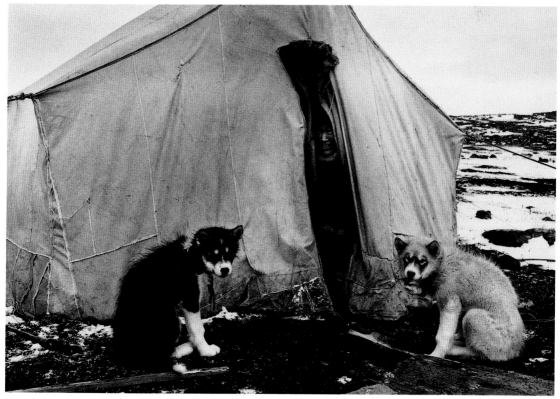

Plate 32.

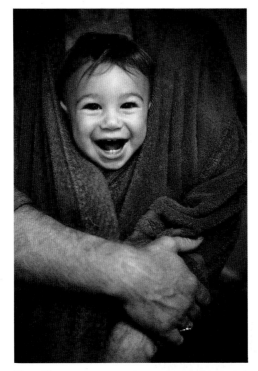

Plate 33.

Plate 34.

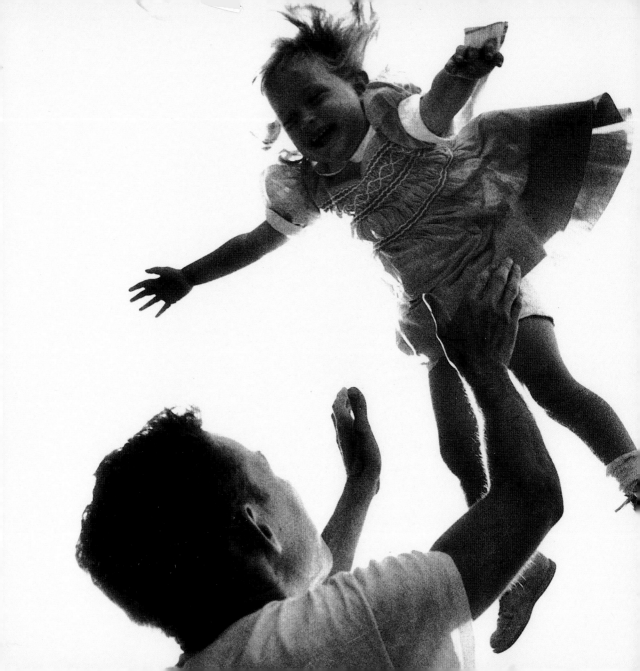

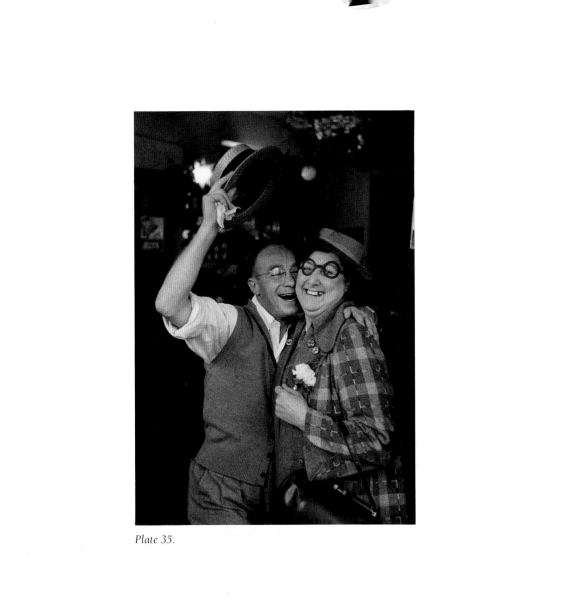

Plate 35.

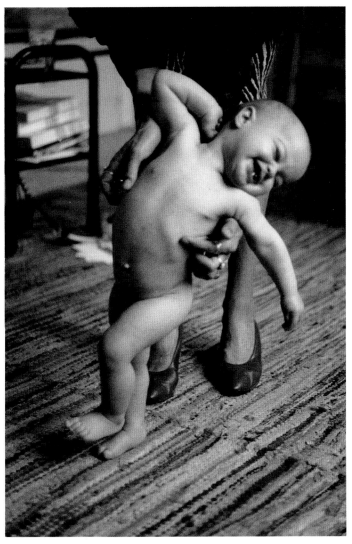

Plate 36.

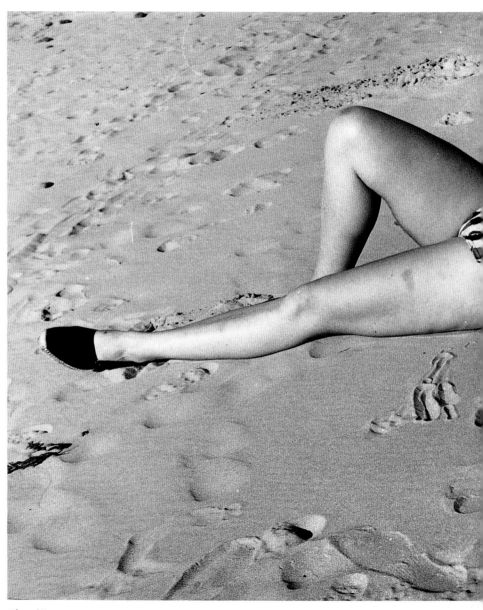

Plate 37.

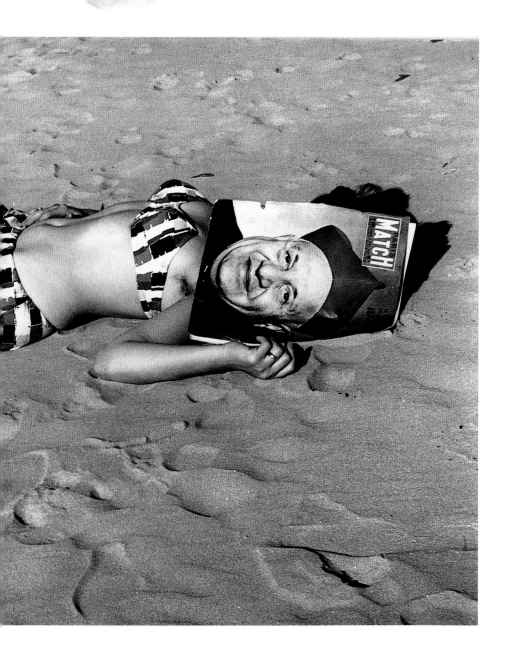

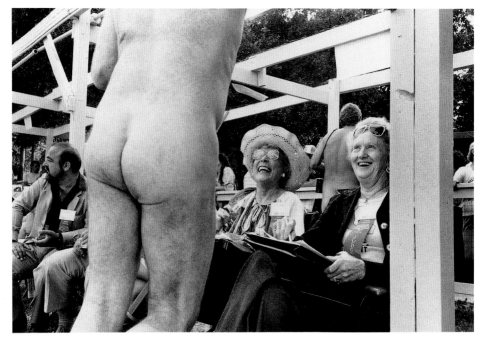

Plate 38.

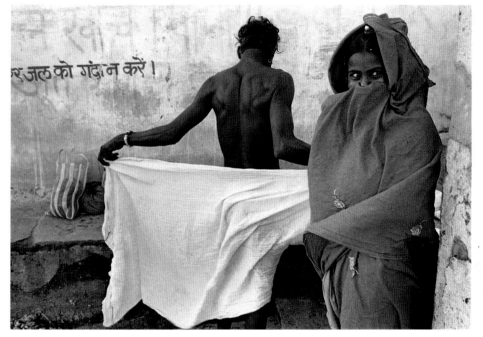

Plate 39.

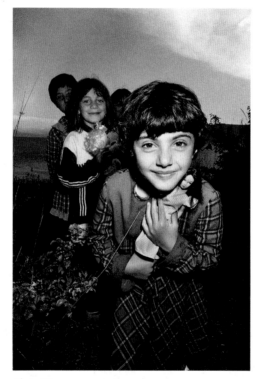

Plate 40.

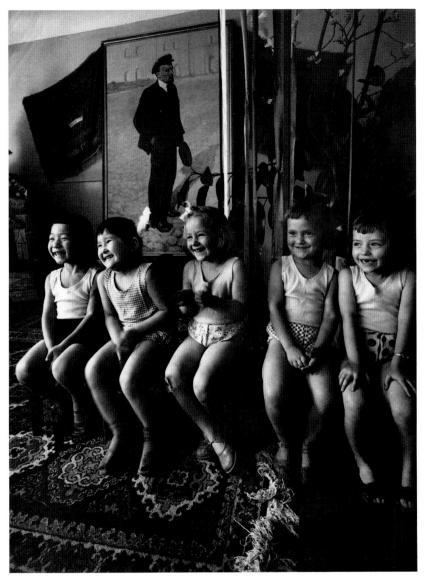

Plate 41.

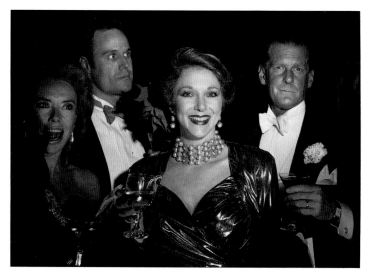

Plate 42.

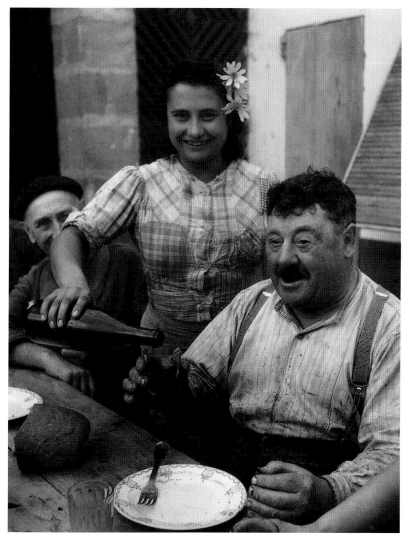

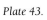
Plate 43.

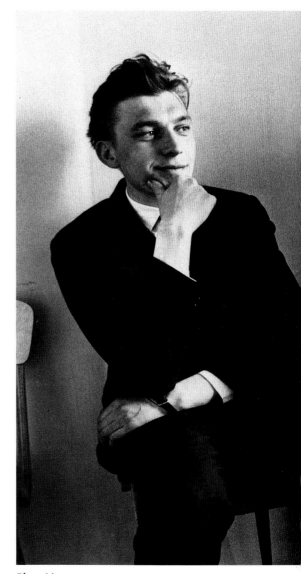

Plate 44.

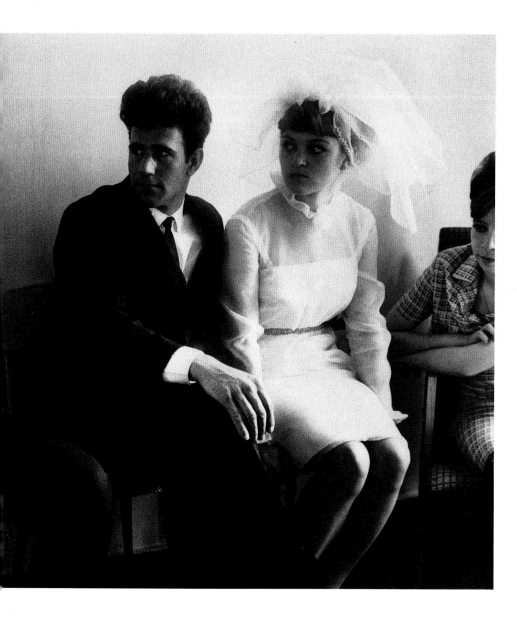

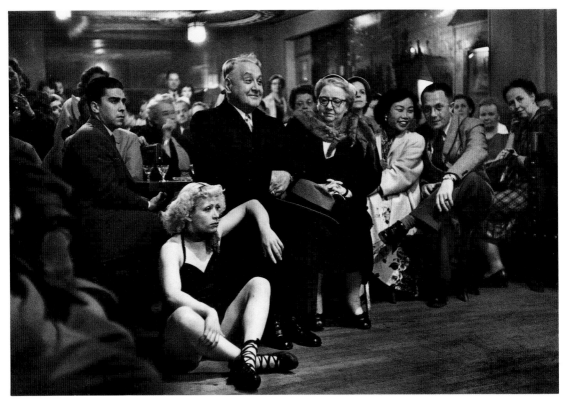

Plate 45.

Plate 46.

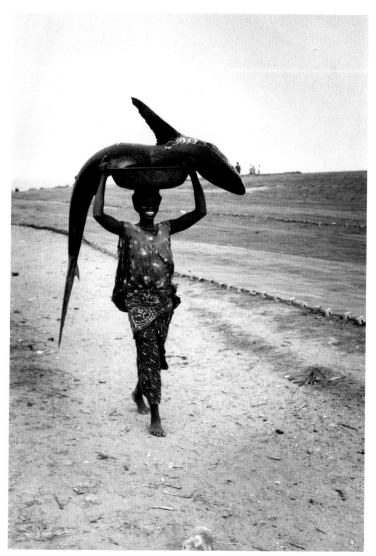

Plate 47.

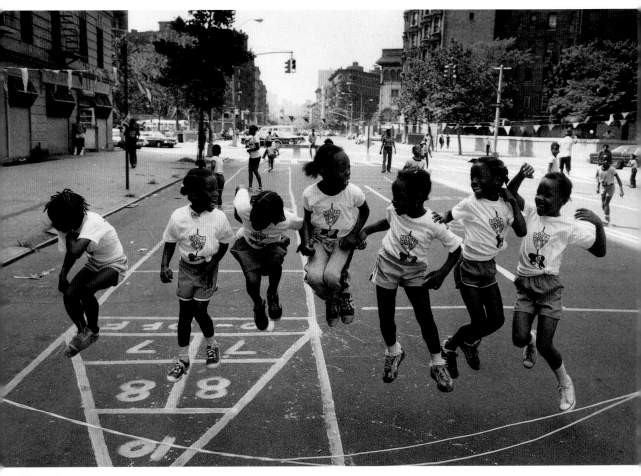

Plate 48.

Plate 49.

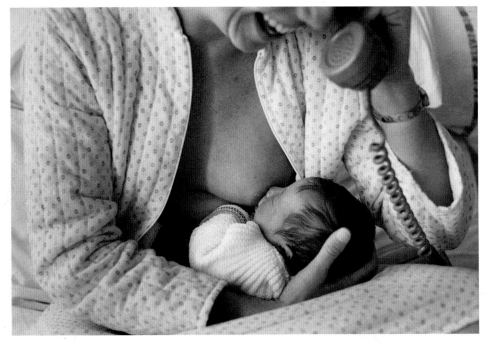

Plate 50.

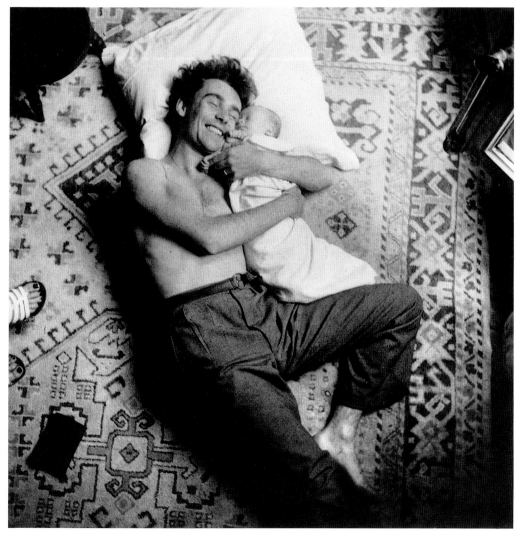

Plate 51.

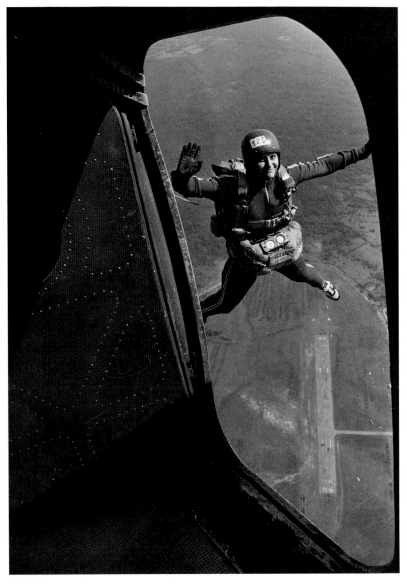

Plate 52.

Plate 53.

Plate 54.

Plate 55.

Copyright Credits

1. *Texas*
 Henri Cartier-Bresson
 1947, © Henri Cartier-Bresson /
 Magnum Photos

2. *La Fille Sans Ses Dents*
 Sabine Weiss
 1949, © Sabine Weiss / Rapho, Paris

3. *Cuban Refugee is Greeted by His
 Grandaughter, Key West, Florida*
 Eugene Richards
 1980, © Eugene Richards /
 Magnum Photos

4. *Untitled*
 Guy Le Querrac
 n.d., © Guy Le Querrec /
 Magnum Photos

5. *New Haven,Connecticut*
 Elliott Erwitt
 1955, © Elliott Erwitt /
 Magnum Photos

6. *Dirty Dozen*
 Anonymous
 n.d., © Bettmann Archive

7. *Psychedelic Burlesque*
 Mary Ellen Mark
 1968, © Mary Ellen
 Mark Library

8. *Untitled*
 David Barr
 n.d., © David Barr / Black Star

9. *Four Boys, Vecors Region, France*
 Robert Capa
 1944, © Robert Capa /
 Magnum Photos

10. *Roller Coaster 1950's*
 Grace Robertson
 1957, © Grace Robertson / Courtesy
 Zelda Cheatle Gallery, London

11. *Town Meeting*
 Arthur Witmann
 n.d., © Arthur Witmann / St. Louis Post
 Dispatch / Black Star

12. *Smiling Monk, Tiktse Monastery,
 Ladakh, India, 1985*
 Linda Connor
 1985, © Linda Connor

13. *San Augustin de Oapan, Mexico*
 Abbas
 1984, © Abbas / Magnum Photos

14. *Retirement Home in Ivry, France*
 Martine Franck
 1975, © Martine Franck /
 Magnum Photos

15. *Untitled*
 Sylvia Plachy
 1966, © Sylvia Plachy

16. *Rue Mouffetard, Paris*
 Henri Cartier-Bresson
 1954, © Henri Cartier-Bresson /
 Magnum Photos

17. *Eunuch of the Imperial Court of
 the Last Dynasty, Peking*
 Henri Cartier-Bresson
 1949,© Henri Cartier-Bresson /
 Magnum Photos

18. *The "Unit"*
 Steve Woolley
 1986, © Steve Woolley